A VISION OF VENICE IN WATERCOLOUR

KEN HOWARD RA

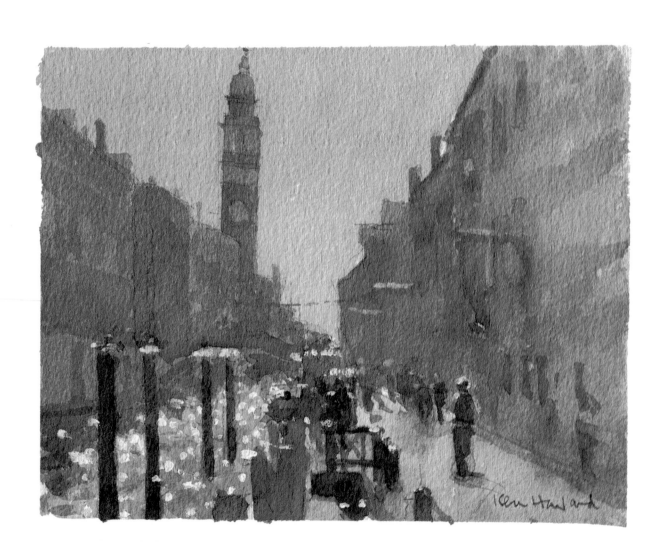

A VISION OF VENICE IN WATERCOLOUR

KEN HOWARD RA

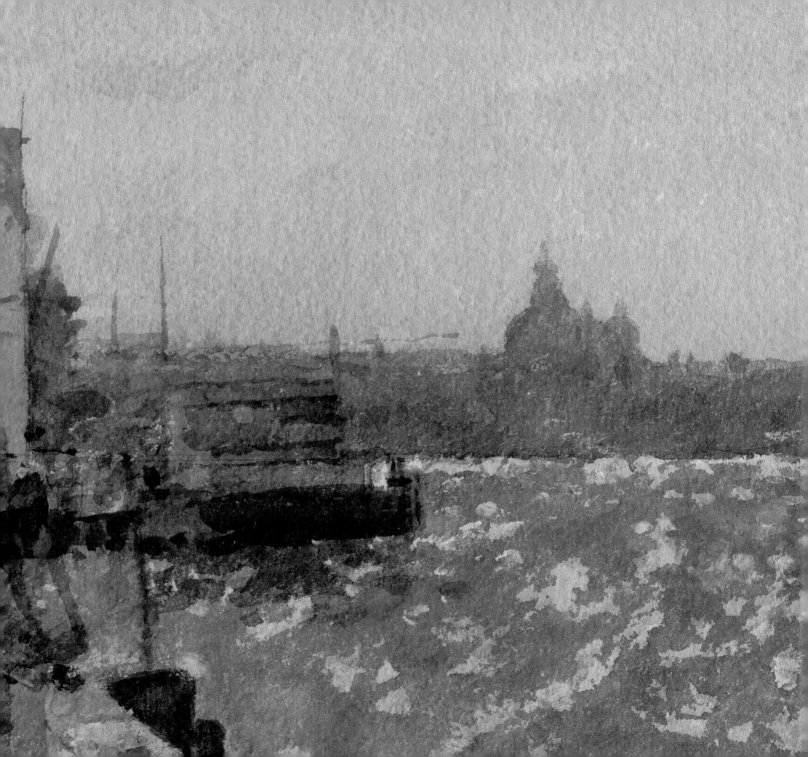

Ken Howard

CONTENTS

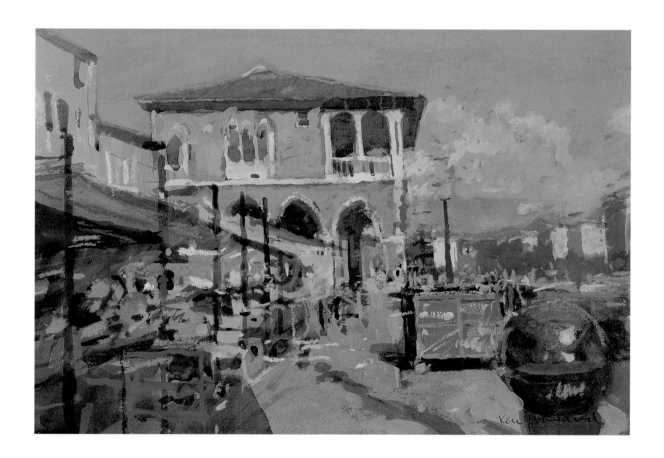

KEN HOWARD RA *by Michael Leitch*

There is a flair and gusto about Ken Howard's work which many collectors, and more casual viewers too, find immediately attractive.

Particularly in his oil paintings, the speed and skill with which he gets to the heart of subjects as diverse as a Cornish beach scene or a collection of pots and brushes in his London studio, are both striking and impressive. In his watercolours, the effects are more subtle but his primary concern, the daily struggle to capture the light as it constantly changes before his eyes, is no less evident.

There is another important difference in his approach to the two media. This has to do with the essentially suggestive, almost elliptical, nature of his watercolours. As he says: 'The nice thing about watercolour and drawing is what you leave for the viewer to fill in for themselves. When you work in oil, particularly in tonal oil, as I do, you

are working in a quite descriptive way. But with watercolour and drawing you can just touch the subject, and the viewer then fills in what they want to. I think this is exciting to do. It's something you can't hope to achieve in oil.'

Ken Howard was born in London in 1932 and studied at the Hornsey School of Art. After National Service in the Royal Marines, he studied further at the Royal College of Art in London and was then awarded a British Council Scholarship to Florence. His first one-man exhibition was held at Plymouth Art Centre in 1955, and since then he has had regular shows in London, particularly at the New Grafton Gallery and more recently at the Richard Green Gallery, and has also exhibited abroad in Cyprus, Hong Kong, India and South Africa. He became an Associate Member of the Royal Academy in 1983 and was elected a Member in 1992. He is also President of the New English Art Club.

Throughout his career, Ken Howard has ignored fashionable schools and trends in the pursuit of his own brand of pictorial realism, painting the world around him in a way that opens people's eyes to the beauty of everyday forms. In the 1980s he went to Northern Ireland as

Danai band, Nepal, pen and wash drawing. This is typical of a drawing in which the subject is constantly moving. In the lower half, the musicians were playing all the time Ken Howard was trying to draw them. In the upper half, the figures were resting. The two parts of the drawing have a completely different feel to them – the one suggesting movement and the other one static.

Public Washhouse, Sana'a, Yemen, watercolour. This was done in Sana'a, the capital of Yemen. It still had a remarkably medieval atmosphere which attracted the artist. The houses in the background are made of mud and straw and rise to four or five stories. Howard wanted to capture this medieval strangeness before it disappeared.

an Official War Artist, and the street scenes and views he painted there, the graffitti and the bomb damage, added a new kind of hard realism to his approach. He recalls:

'There are now two sides to my work. Going to Northern Ireland made me look very hard at what I saw there, and also made me want to go out and paint more obviously attractive subjects like Venice, the seaside in Cornwall, and beautiful women. Before Northern Ireland, I painted a lot in the city, doing architectural and industrial subjects, but afterwards I found myself moving towards more, if you like, visually agreeable subjects. Then I went out to Bosnia to do another spell in a war zone, and after that I realised that I actually need a charge from that other, darker side to help me to see the beautiful things more clearly.'

In this book, readers will see Ken Howard at work in one of his favourite locations, the squares and canals of Venice. As the paintings rapidly take shape, he reveals himself as a man of variety and verve, and consummate artistic skill. Not widely applauded virtues in today's art world, but that has never been his concern.

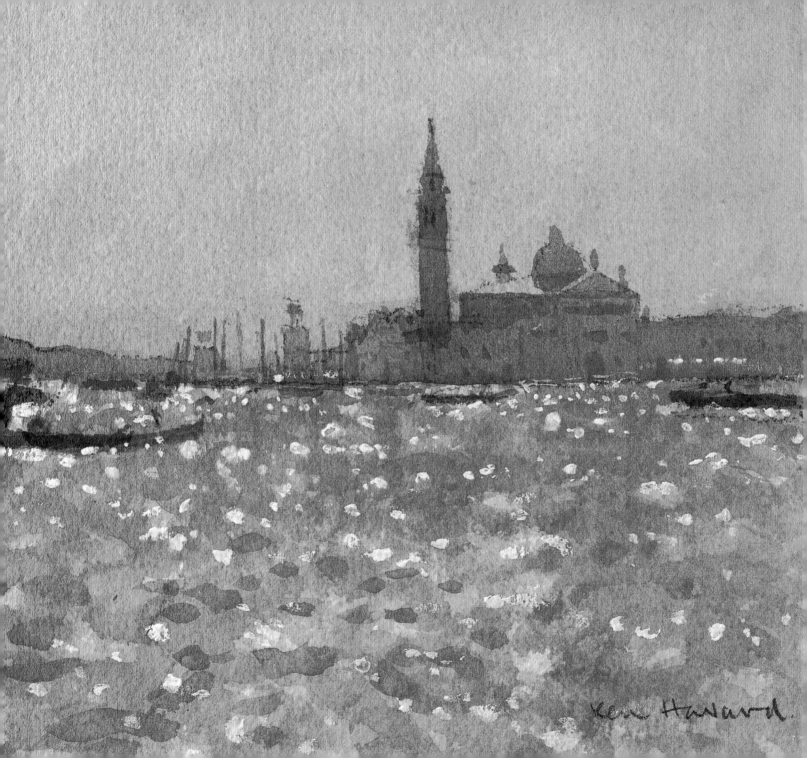
Ken Howard

INTRODUCTION

I never work large with watercolour. Some people have a great big piece of paper and work very large – I never do. I suppose this is because the paintings are usually about light and therefore you've got to get them done quickly. Also I think some of the most beautiful watercolours ever done have been on a very small scale.

I suppose my philosophy of painting is very simple, particularly in this day and age. It is about three things really, it's about revelation, it's about communication and it's about celebration. And if you take the first one, revelation, what I mean by that is quite simply revealing to oneself through doing the painting and thereby revealing to other people a way of seeing the world. You open other peoples' eyes to your

way of seeing and that is all-important. Communication – very simple. I have always believed that art must communicate with a public. That's not why you do it, you do it for yourself because you can't help it. But, in a way, if your ideas are not communicated to other people then what is the point? You are just speaking to yourself, you are just contemplating your own navel. The third one, celebration, is one that I know a lot of people will argue with, but for me I like painting, music, literature, etc, to raise me above the norm, to raise my spirits and give me a sense of celebrating. I suppose for that reason my basic interest in painting is light. I think light is a celebration of nature. That to me is what I call celebration. What I want my art to do basically is to make people feel elevated, feel a sense of celebration about life and about the world about them and in this case, when I work in Venice, a celebration of Venice, because of all the cities in the world Venice is the one that celebrates life, it celebrates light, it celebrates art and it is a celebratory place.

So what I would like to do now is take you and show you my Venice, not everybody's Venice, not the Venice of the picture postcard, but the Venice that I see in terms of watercolour, my Vision of Venice.

Opposite *The Piazza San Marco on a rainy day. Here the reflections in the wet paving stones were as important as the church. I have arranged the figures so that they all move along a diagonal path which funnels the eye towards the door of the church.*

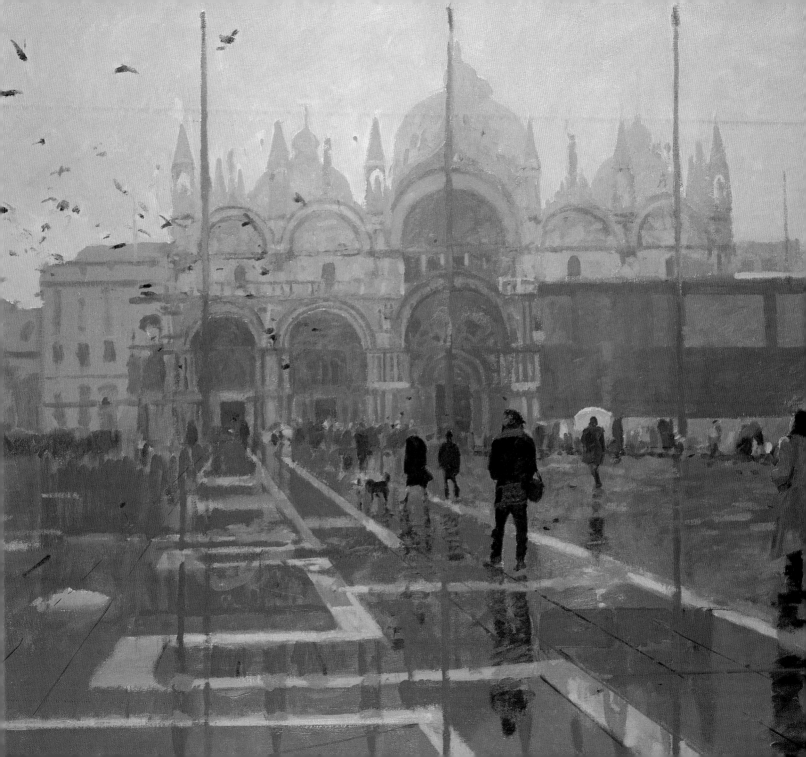

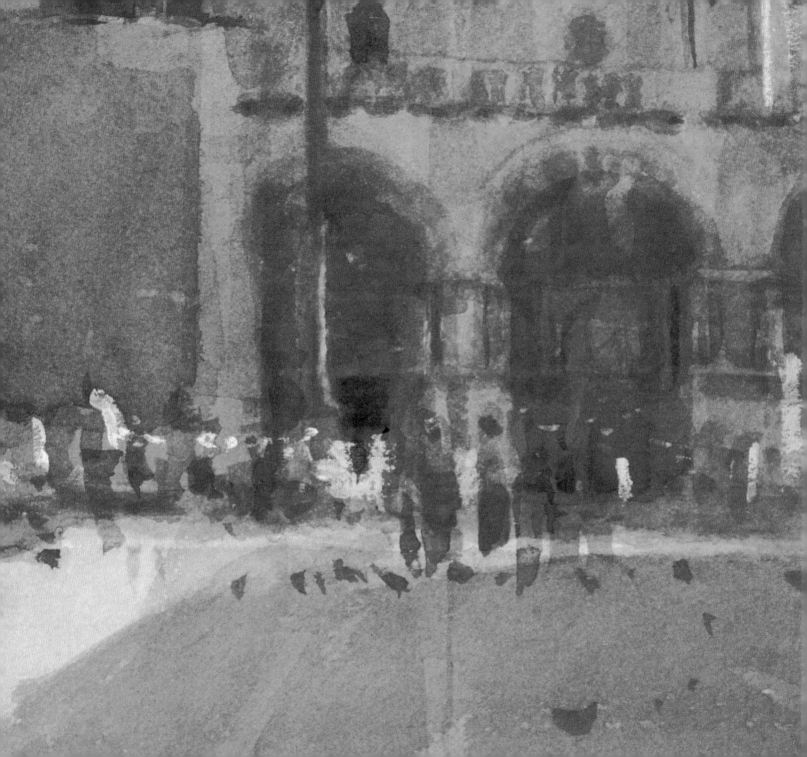

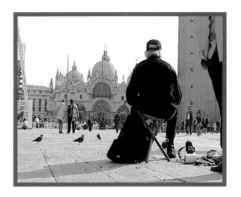

PIAZZA SAN MARCO

Opposite *This is a detail of a painting I did from slightly to the right of where I am sitting in the photograph above. I was pleased with this picture because it seems to have quite a lot of detail in it, but if you look more closely it is all very amorphous. This is one of the strengths of watercolour, suggesting something and then leaving it to the viewer to fill in the detail.*

I suppose I have painted this subject off and on now for about fifteen years and I never come into this square and don't get a buzz when I look at it. To me it's almost like the human figure. With the human figure you don't say, 'Oh I've painted it once,' and therefore you don't paint it any more, you paint it all your life. It's not very often buildings do that, but for me this building, in a funny sort of way, has got the life of a human figure. It always offers you something new whether it's the light or the angle or the people in relation to it or whatever.

Although I am going to work on two pieces at the same time, I hope that I won't be working on two completely different images. I will probably use the two images and change them as the light changes, but

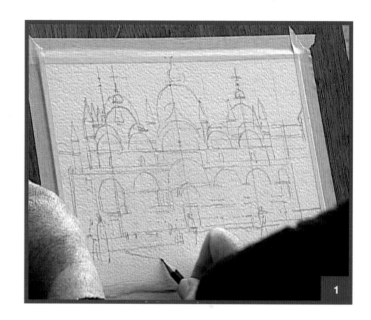

I'm not really doing it for that reason, I'm doing it because, with watercolour, once it is of a certain wetness you can't control the drawing any more.

I am using basically transparent colour. I don't use the non-transparent colours all that much. Yellow Ochres are a more opaque colour, but I tend to use much more Raw Sienna. Cobalt Blue is a more opaque colour, and I tend to use more Ultramarine. Vermilion or Cadmium Red are more opaque colours, and I tend to use more Alizarin Crimson, but I don't think you can obey rules. It's no good going away and thinking, ah, right, if I don't use any opaque colour I'll

1 *This drawing has quite a lot of information in it. Partly this is because the façade of San Marco is complex, but partly it is because at the beginning of the day, when I am feeling my way forward, I draw much more for a watercolour than I do at the end of the day. Later on, after you have been painting for five or six hours, you are in such flow that you already know what you want.*

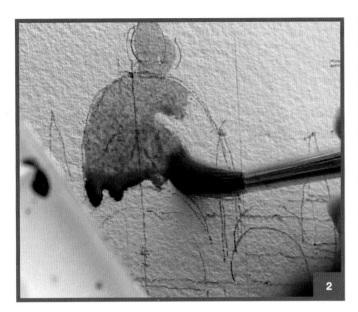

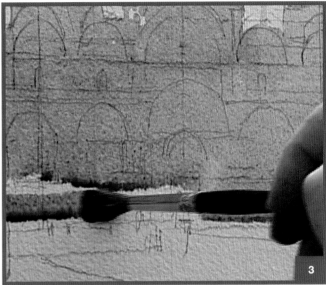

2/3 *Laying in a grey wash – a mixture of Burnt Sienna and Ultramarine – over the front of the building, and letting it run down.*

be alright. Painting basically must grow as you do it. And I'm not really a watercolourist. A friend of mine, he was from the North, said, 'Watercolour is like pushing a puddle around,' and I'm not really a pusher around of puddles. I think of watercolour really as an extension of drawing. I often call them watercolour drawings, not watercolour paintings.

I am running the wash right over the whole thing because watercolour, above all else, is about the wholeness of the thing, not about bits and pieces of detail. Watercolour painting, like drawing, is the thought process. What I'm doing is putting down what I am thinking about.

The first one is now drying and I've started on the other one. This time I have decided the other one was a bit cool, so I am going to establish the main shape with a warmer colour.

One of my great heroes is Sickert, and he used to say, 'When you're drawing, always indicate that you have noticed something,' and that, in a way, is what I do when I use watercolour. Right at the beginning I am indicating to myself that I have noticed something.

I'm working on a fairly rough 'Not Arches' paper (which means it is not hot-pressed). I usually use a very heavy watercolour paper, about

4 *This wash can now dry while I turn the board round and work on the second painting on the other side.*

18

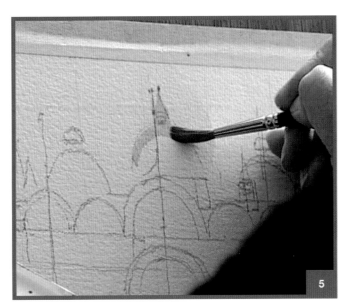

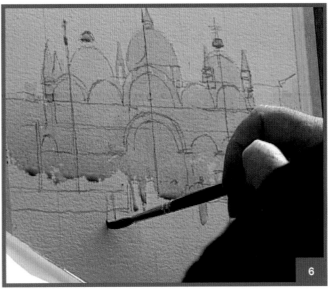

5/6 *Here I am looking for a warmer tone and using Yellow Ochre. I let the paint run down, but because I am working with a piece of board wedged between my knees, I can quickly adjust the angle of the board so the paint does not drip down or run further than I want it to.*

300 lb (640 gsm). This paper is just stuck down with masking tape. You'll see at the end, I strip the masking tape back and then I can see how deep my colour has gone because there is a white edge running round it like a mount and that's quite useful.

Russell Flint made marvellous use of these earthy, transparent washes, like in this case, where you get these warm washes made up, for instance, of Raw Umber and Windsor Blue, both of which are beautifully transparent. Well, Windsor Blue is very transparent and Raw Umber is relatively transparent. Even though watercolour isn't like oil, where you're getting exact tonal values, nevertheless you have

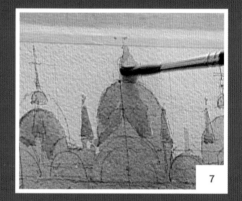

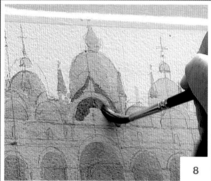

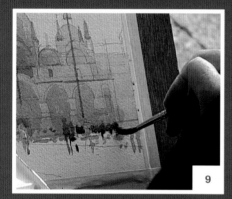

7/8/9 Laying in a wash in three areas of the building. In the foreground I am indicating some of the figures. These look quite strong at the moment, but when I lay on the next wash it will lift a lot of that colour off.

got to take into consideration the way one thing affects the next. So, for instance, in this case you get the domes on the top of the church, relative to the sky, looking much darker than if you were to take those domes and move them to the bottom of the building. Everything has got to be related to what it is next to in the painting and there is no such thing as an absolute correct value in relation to nature. Everything depends on everything else.

Although it's slightly opaque, I want to get a little bit more strength into it so I am going to put on a thin wash of Yellow Ochre. I'm using this very thin wash to pull the whole thing together because this wholeness is important; in all painting or in all art really, at least to me it is. The harmony, pulling the whole thing together in harmony rather than leaving it as a lot of disjointed, individual accents.

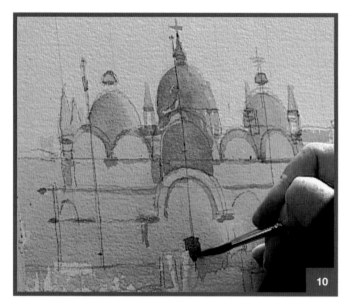

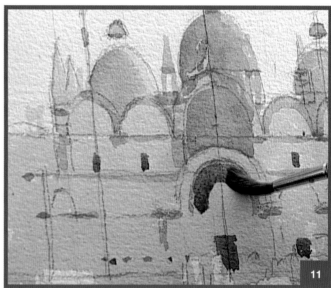

When you turn back to the other picture, it's surprising how you see it freshly, relative to the other one. It's like walking away from the subject, as you do with an oil. You walk away from it so you can see it from another point of view.

I do my watercolours by building up wash upon wash. Once a watercolour wash has dried then, to a great extent, it's permanent so that when you put the next wash over, it doesn't disturb the wash underneath. The next wash works as a transparent glaze, like in oil painting, over the top of the colour underneath. Sometimes, if you build up too many washes in a picture, it can begin to go dead.

10/11 *Keeping the shapes simple. Although the actual building is quite heavily decorated, it is better to suggest what is there rather than get involved with a lot of detail.*

Opposite *This is part of an oil painting from a slightly different angle. Here, too, I have laid thin glazes over the sky. The difference is that in oil painting you have to wait until the previous layer is completely dry, otherwise the colours go muddy.*

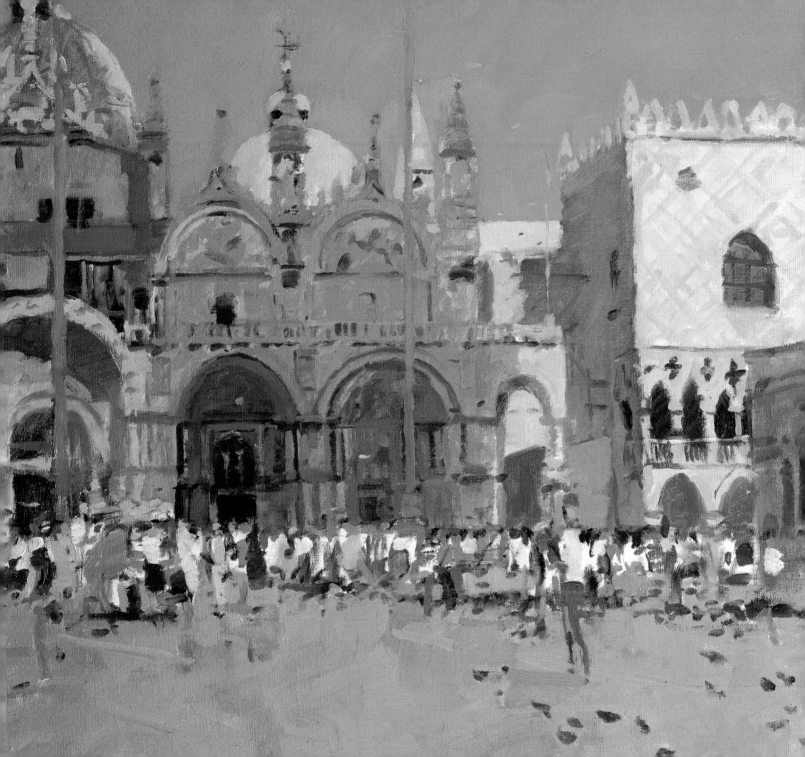

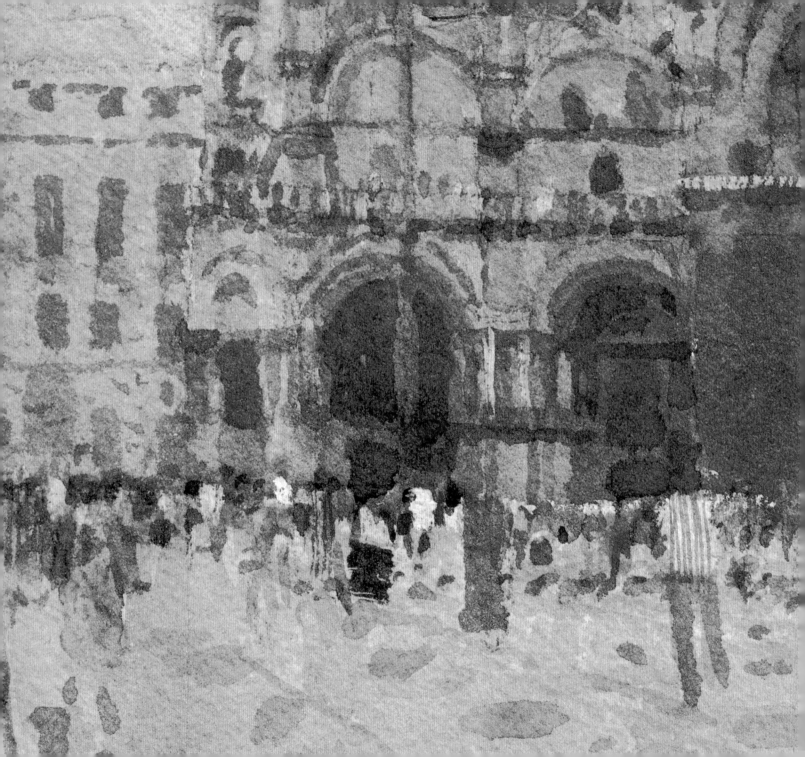

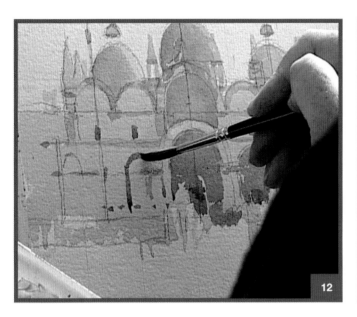

12

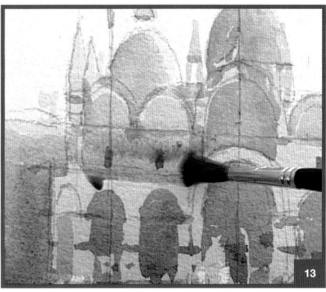

13

12/13 *If you use this glazing method, keep to transparent colours such as the ones shown here – Burnt Sienna and Ultramarine.*

Notice also the way I am trying to keep things simple, like the arches at the bottom. When you look at the actual church, you'll see that the arches at the bottom have got quite a lot of variation in them, but if you half-close your eyes and look at those arches then you see them first of all as an overall shape, and then you decide later just how much variation you're going to build in. But if you were to start with the variation, you would never get that whole feeling of their basic shape.

Now I am going to put on a wash of Alizarin Crimson, then another one of Ultramarine.

I'm going to put a wash of Alizarin Crimson over the whole of the sky and let it run through. When I paint the sky, I gradually build towards this light but nevertheless colourful sky which is made up of wash upon wash upon wash, gradually building up the colour I want and gradually building up the tonal value I want. Then while that pink wash is drying, because I am going to put a blue wash over it, I am going to put a blue wash over this other one, pure Ultramarine.

From a very early age I have always licked my brush when working with watercolour. It's got the very practical reason of taking the surplus paint out of the brush and bringing the brush to a point, and I must admit it has never done me any harm. I've been doing it for the last fifty years, so I must have quite a stomach full of paint, I suppose.

This is Raw Sienna, which is very transparent. The danger is that

14/15/16 *When you use washes like these two – Alizarin Crimson followed by Ultramarine – make sure you keep the colour weak each time. It is always possible to strengthen your colour, but very difficult to take it away once it is on.*

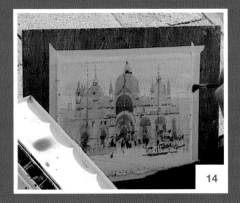

14

15

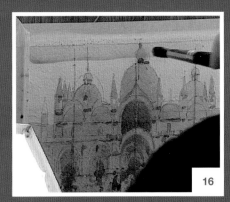

16

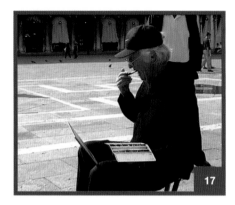

17

when you're painting you paint what you know is there. For instance, we know skies are blue, so the temptation is to paint them really blue. But if you look at the sky hard, you will usually see that there are a lot of other colours in the sky as well as blue. So when I build my sky up, it's usually built up, maybe right at the beginning, with a wash of Alizarin Crimson and then over that I'll run a wash maybe of Raw Sienna and then I'll run a blue wash over that. And then it starts to take on what we think of as the blue quality of the sky, but in fact there are a lot of other colours there.

If you go on with a watercolour too long you just kill it, mainly because the light is changing. At the moment the light is not obvious because it's behind, but the image is changing all the time.

A picture is done when it gives back to you the sensation that you felt

17 *Here I am licking the brush to give it a point and make it drier for the next bit of painting. For small children watching, this is the highlight of the whole thing – waiting to see if he will give it another lick, and when.*

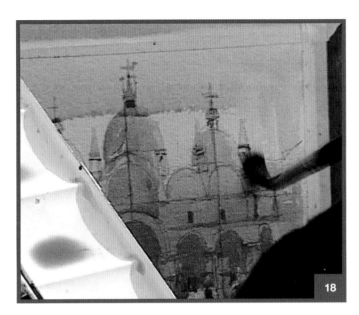

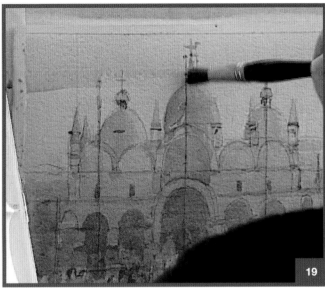

18/19 *Building up the sky with a series of washes to reflect the light at this time of day. Here the wash of Ultramarine is followed by Yellow Ochre.*

when you first saw the subject. So I'm getting near to that stage. When I'm getting near to the very end, I've very often lost my really light accents and that is when I turn to my Chinese White. For me this doesn't diminish the purity of the watercolour. If I now started to paint the sky with a lot of white in it, then I would be beginning to move into the area of gouache. When you're painting, it isn't just a question of painting what you are seeing in front of you. What you are trying to do is give the whole feel of the subject, and part of this square is all the noise of people talking, and the sound of the musicians playing in Florian's.

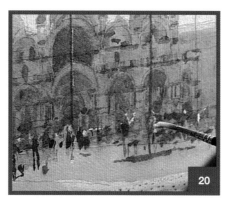

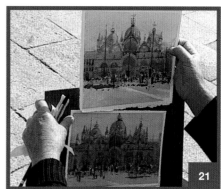

Here are the two finished watercolours. You will see that they are in many ways different. The first one is much more violet and cool, particularly the church, and then by comparison the sky is much warmer, much yellower. Whereas if I paint the church much warmer, as in the second version – with that yellowy orange – when you look at the sky you automatically see it as bluer, because the eye compensates and makes you see the complementary contrast in the colour next to it. So one of them is about purple and yellow, and one of them is about orange and blue.

20 *Now, towards the end, once all the washes have been laid, I am putting in some light accents using Chinese White. I always hold my Chinese White back, then use it to bring back any lights that I have lost.*

21 *The two finished paintings: the warmer one and the cooler one.*

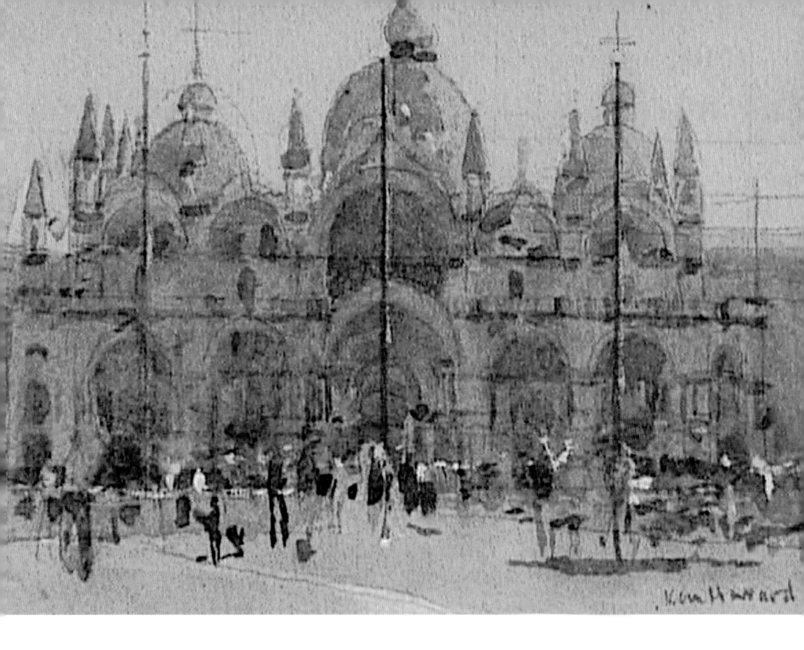

"of all the cities in the world Venice is the one that celebrates life, it celebrates light, it celebrates art..."

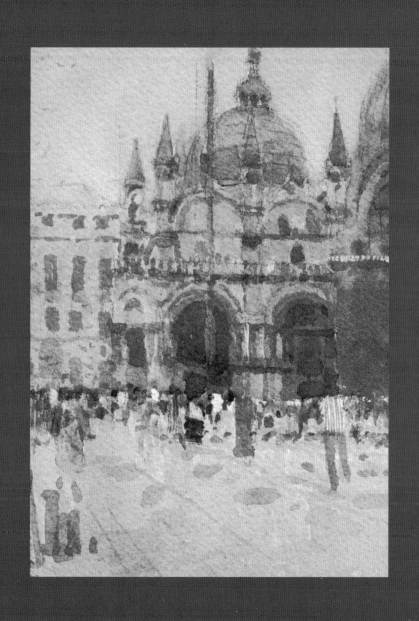

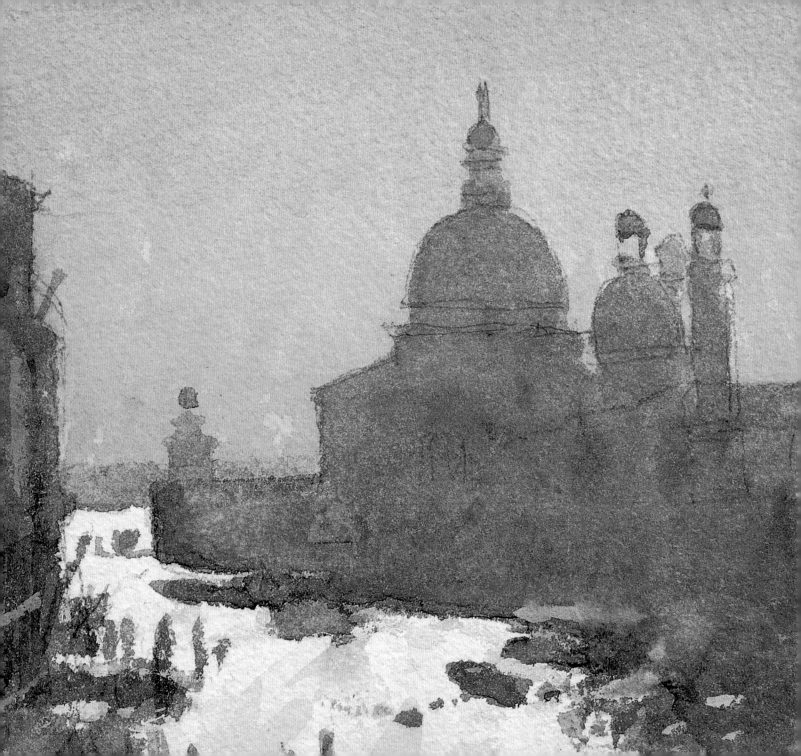

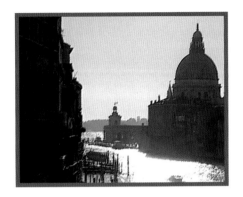

SANTA MARIA DELLA SALUTE

Previous page *Full version of the watercolour illustrated on page 24.*

Opposite *Detail of the completed painting shown on page 53.*

This morning I've come up to the Accademia Bridge. Apart from the San Marco subject, this is probably the other great subject of Venice. It is the sort of subject which when I first came to Venice I thought, I can't possibly paint that subject, it's been done by everybody. After a while I realised the reason it had been done by everybody is that it is such a wonderful subject, and if a subject is that great it's like nature itself, it can be interpreted in a million ways, not just in one way.

I am going to work on two paintings, because the nature of the subject will mean that I will have to work quite wet. So I'll need to keep on turning the board over. I am just running one wash right over the whole lot, because that is all one can see at the moment. As the sun

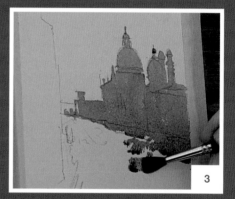

1/2/3 Laying in a fairly dark colour over the dome of the church, and bringing the same colour down over the water.

goes up in the sky it reveals more, but the danger is you end up with two paintings on one surface – the effect as it is now and then the changing effect. It is inevitable to a degree, because obviously the light is changing every minute. That's why it is important only to paint for a certain length of time. I want to finish these two watercolours in a maximum of an hour, and the light will have changed a lot in that time. You've just got to recognise that if you are going to work on the spot and are concerned with light.

I am starting off establishing the main shape of the subject, and the fact that on the right the subject is in shadow whereas on the left, gradually, the light gets more and more on it. I'm laying it in with one basic colour, a mixture of Burnt Sienna and Ultramarine. This is always a good way to get a grey because if you want it to be a cooler grey you can very easily drop in a bit more Ultramarine, and if you

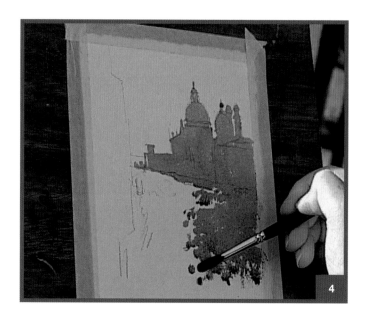

want it to be a warmer grey you can drop in some more Burnt Sienna, so you have got at your fingertips the chance to vary the grey all the time while you are working.

Basically I am using the same colours except that I am letting more of the Burnt Sienna come into the left-hand side. Turner and a lot of the early watercolourists worked a lot with a blue and a brown. It's very, very clear this morning. It is beautiful, it's just very difficult to look at. Somebody once told me I ought to be careful about always looking into the light because I'd damage my eyes, but I have done it all my life. I've always been interested in tone and contre-jour and, touch

4 *Here I am leaving spaces in the base wash to suggest where the light falls on the water.*

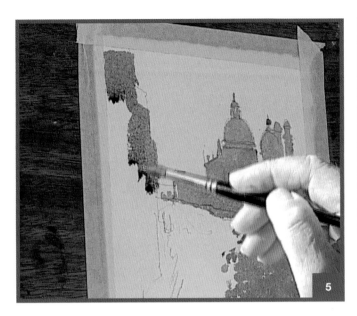

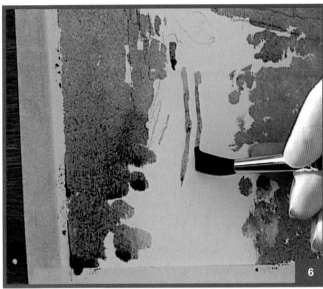

5 *More light is coming onto the left-hand side of this scene, so I have added more Burnt Sienna to the wash to make a warmer grey.*

6 *Posts and shadows on the water. It looks as if I am using a flat-ended brush but this is misleading. It is simply a good, pointed sable brush, which will give you the finest of lines as well as the broadest of washes.*

wood, so far the light has been kind to me and I have been all right.

Now I'm going to leave that wash to dry and lay in the other side. I might let some of the washes stay a bit wetter this morning and gradually the buildings will begin to reveal their detail, and that is the dangerous time. Somebody once described drawing as taking a line for a walk and in a way that's what it is about. You follow from one part to the next, relating the whole, which is the important thing, because with a subject like this there is not a lot of line there anyway. It is all really down to areas of tone.

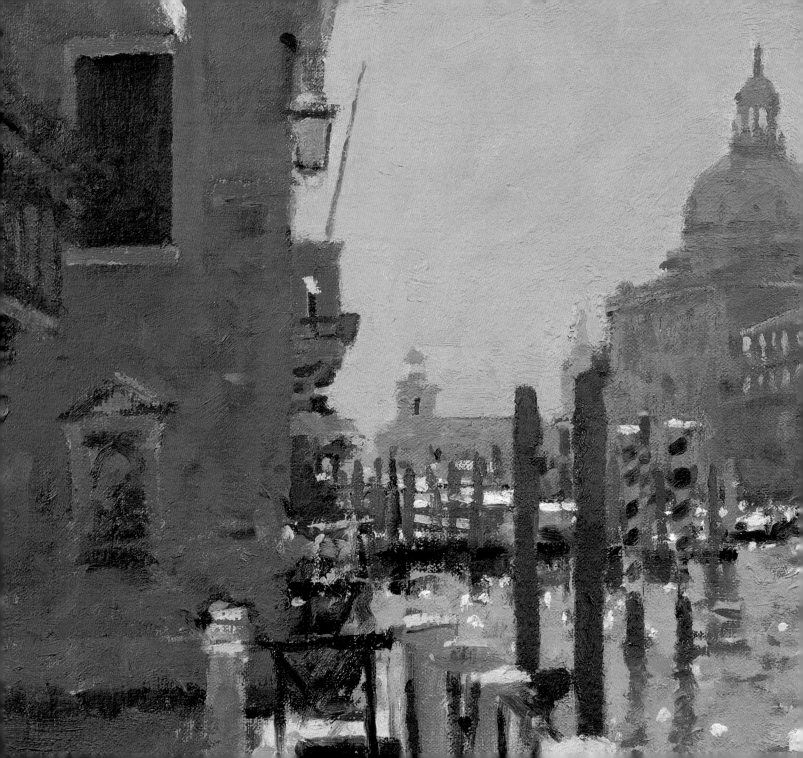

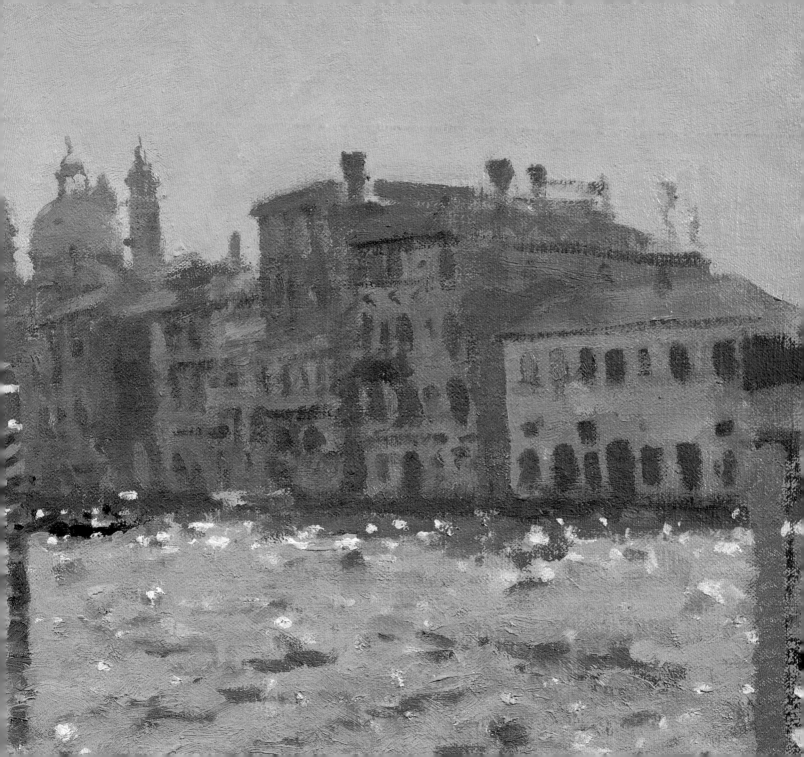

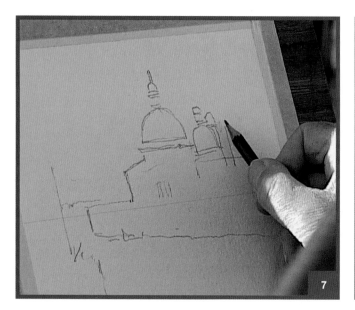

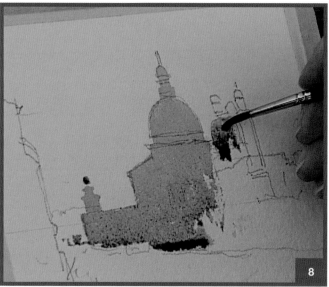

One of the problems working up here of course is that it is the main thoroughfare between the two main islands of Venice. Apart from the Rialto this is the other way across between the Accademia area, or the Dorsoduro as it is known, and the area of San Marco. So you get a lot of people going across, but in a way, once you get involved in the thing, it doesn't matter. It is wonderful to come back to this subject, I gave it up some years ago for the very simple reason that so many people wanted paintings of the subject that in the end I began to wonder if I was painting them for me or because they were needed, and I gave up doing them. But now it is like coming back to an old love, and wonderful to meet it again and see it again. It is one of those

Previous page *Oil painting of the Grand Canal.*

7 *Drawing in the outlines for the second painting. It is a good idea to try drawing without lifting your pencil off the paper. This helps you to think more carefully about the whole shape and where you are going next.*

8 *I have made this colour fairly dark because I am painting into the sun, and the light behind the church is very strong.*

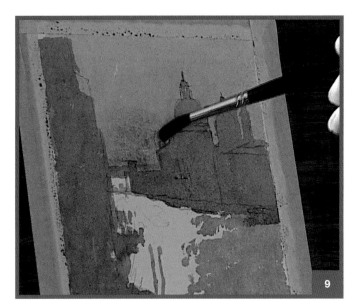

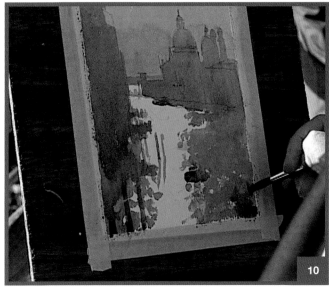

9 *Applying Yellow Ochre to the warmest part of the sky. I always try to put Yellow Ochre on first because it is opaque. You can put other colours over Yellow Ochre, but it is better not to put Yellow Ochre over other colours.*

10 *I have followed the Yellow Ochre with an Alizarin Crimson wash over the whole of the sky, and am taking it down over the right-hand side of the painting, balancing sky and water.*

scenes that never stops giving back something special.

This morning I am keeping completely to the transparent range of colour. Alizarin Crimson, Burnt Sienna and Ultramarine Blue. I'll probably use a bit of Yellow Ochre, even though it is fairly opaque.

You get the lovely traffic on the Grand Canal in the morning, not too much like the great traffic jams that we get in England, but you just get that bit of movement of small boats going up and down, plying their trade, delivering things.

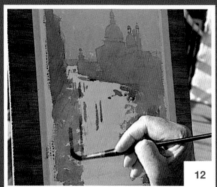

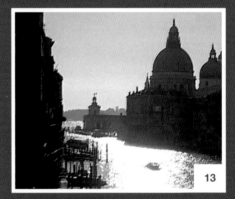

11 *Here the glaze over the sky is especially warm to reflect the brightness of the morning sky, when it has yellows and pinks in it.*

12 *Building up the living scene, with all the mooring posts and the delivery boats that you see on the Grand Canal at that time of day.*

13 *See how bright the light is on the water as the sun gets higher in the sky.*

It's interesting how the painting that you are doing interacts with the subject you are looking at. By that I mean that if you put a warm glaze on the sky and you look up, very often you think, 'Oh no, the sky isn't as warm as that,' and therefore you are inclined to try and cool it down again – or if you give the sky a blue glaze and you look up, you suddenly see how much warmth there is in it. You see this complementary contrast in the subject.

Again, when painting the Salute, because the sky is warm in the morning, in other words it's got yellow and pink and all warm colours, then you see the dome of the Salute as cooler. So for the dome of the Salute you need to put maybe Cerulean Blue, a touch of Windsor Blue, because you're seeing it as a complementary contrast to the very warm sky. Whereas when you get down the buildings and get away from the sky, because it is against the light and because of the

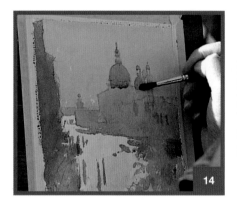 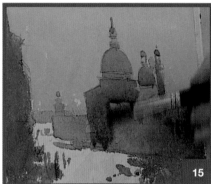 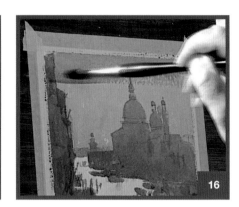

atmosphere, there isn't a great change of colour through that background part, but the optical illusion is that at the top it's more blue because the sky is more yellow and at the bottom it is less blue because the reflection in the water isn't as strong as the warmth in the sky. It is there, the water's still got warmth in it, but it's darker and it's not as obviously warm as the sky. I am not talking about where the light is reflected on the water, but the water around that reflection.

Having put the red on, I'm putting the yellow on now and then I'll glaze the blue over the top of it. In order to get the light off the water, you have got to keep the sky relatively low. When you look at the sky you know it is blue, that's the trouble, and yet it isn't, it's a wonderful, almost coppery colour.

14/15 Now the dome and the lower part of the building need to be made cooler against the red of the sky.

16 Putting a glaze of blue over the yellow, to keep the sky relatively low.

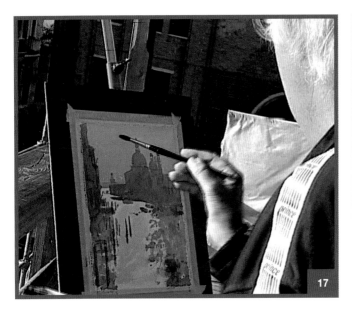

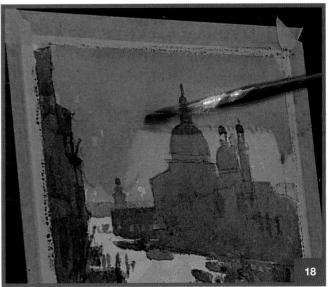

17 *Switching to the other painting, I am using a glaze of Alizarin Crimson.*

18 *This is a yellow glaze, and I will follow it with one of Cerulean.*

You must always keep on making sure you paint what you see, not what you know, because what you know is not surprising and is very seldom true. You only know something about one subject for one time of day, everything else is for the first time. At one time I was coming out onto this bridge at the start of every day, and yet every morning I saw something different in it.

I am going to try a glaze of Cerulean, it might go terribly muddy but I can get rid of it if it does. When you first put it on you think, 'Oh no, I've made it too dark,' but wait until you get it over everything and then make up your mind. You can always dab it off again. I very often

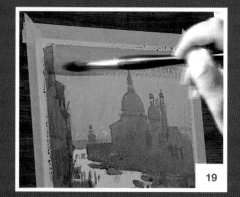

19

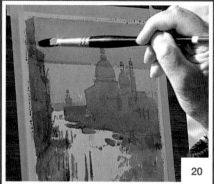

20

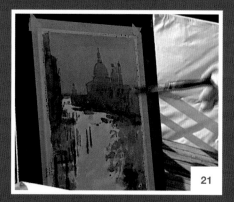

21

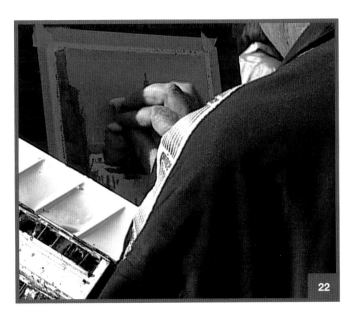

19/20/21 *Applying the Cerulean. This is a strong colour, so you need to be careful to make your glaze fairly weak.*

22 *Dabbing off some of the Cerulean. A good tip is to use toilet tissue, which you can then throw away, rather than a rag which may be dirty or have other colours on it.*

go through a struggle, wondering whether watercolour should be something which is put on in one wet, in one immediate wash. When you look at the watercolours of Sargent and even Turner, they look as if there was one wash put on and that was it. But I just don't naturally work in that way, I love the feeling of building up wash upon wash upon wash and therefore getting the transparency and the mystery of the colours of nature. But if you do it too much, or you use too many opaque colours, you finish up with mud.

It's nine o'clock, just over the hour, and it's getting near to the time to call it a day, even though there are always things you want to do. You

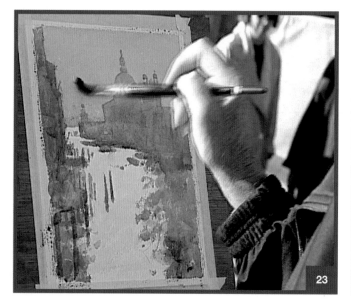

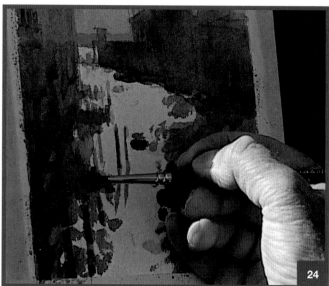

get to the stage where you lose more than you gain by going on with it.

Here I've got back into using my Chinese White because, while I was building up that tone of the water around the reflected light, I naturally lost all my white paper and when you look at the subject, of course, that is exactly what it is like. It's not until I take the masking tape off that I can really see whether I have managed to push the tone low enough to give the value to the true light which is on the water. If you look at the true light on the water, which it is now possible to do, you can see how low in tone the sky is. Turner would have made a meal of this if he had seen that light and atmosphere! Mind you, he

23 *Here I am bringing back some of the yellow which had been lost under the Cerulean.*

24 *We are coming to the end of the time I have set myself for these paintings, and I am just touching in some foreground detail.*

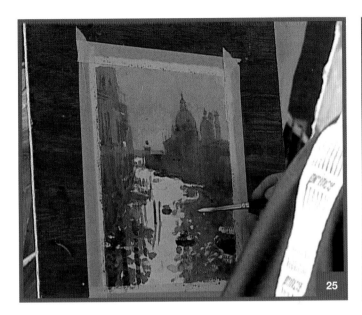

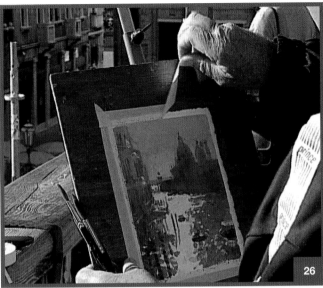

25 *Putting in highlights with Chinese White to build up the tone of the water around the reflected light.*

26 *Taking off the masking tape. This leaves a white frame around the painting and helps me to see if I have managed to get the right tones for the sky and the light on the water.*

would have done it in about ten minutes. Instead of my two paintings, he would probably have done a sketchbook full by now.

It's a lovely subject, I could paint it forever. But you can't, of course, because that is just *repeating* yourself. As if you could ever repeat that view! Every day it's different.

It's almost as if the first colour you put down is the key to the whole picture, and then you make all the other colours subsequently work in relation to that first colour. Therefore, each time you paint the subject, it will be different because that first colour will always be somewhat

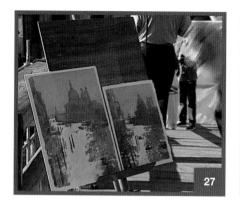 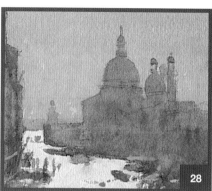 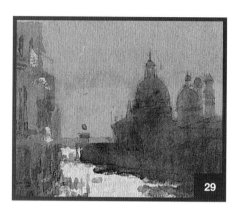

different, you will always see it differently: 'Ah, I see it cooler this time, I see it warmer this time.' And once you have stated that first colour, then the rest of the painting will automatically relate to it.

27/28/29 *The two paintings. Both are warm in tone, reflecting the strength of the light in the sky as the sun was still coming up.*

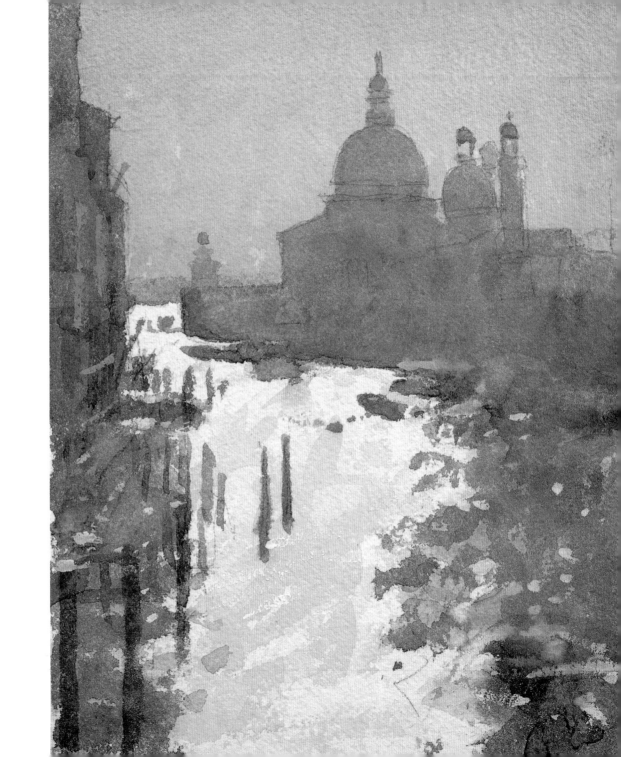

"Venice is constantly giving you contrasts, from being in a sort of dark alley and then suddenly coming out into this blaze of sun in the square."

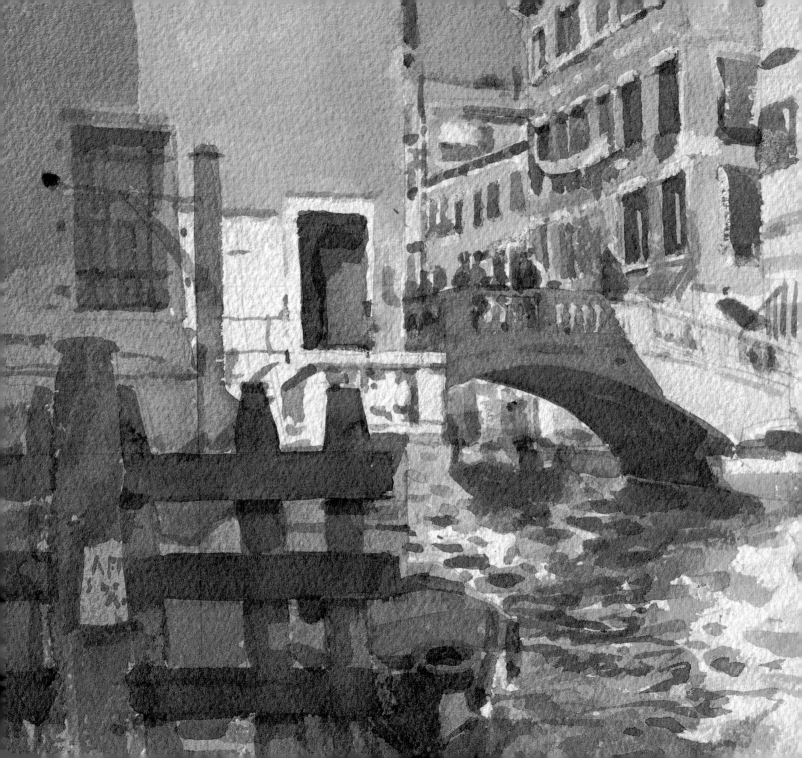

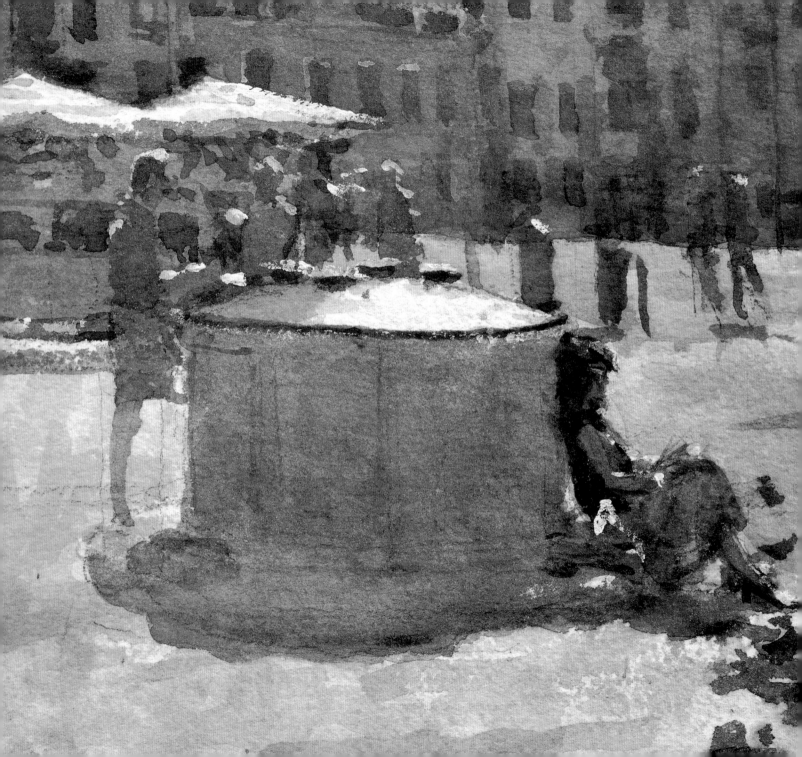

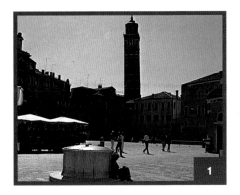

CAMPO SANT'ANGELO

Opposite *Detail of the completed painting shown on page 71.*

1 *The square with its famous leaning campanile.*

This is Campo Sant'Angelo, where again I have worked for some time. Ten years ago, I was working here and a certain girl came and sat down by the fountain there to eat a panino for her lunch. I just carried on and I thought, well, I'll include her in the watercolour. So I did, and when she had finished her lunch she came over and said to me, 'What's your name?' and I said, 'Oh, you won't have heard of me,' but I gave her my name anyway. Three years later, I got a letter saying that she had been to the Royal Academy in London, and realised that the painting she liked best in the exhibition was by the man who painted her in Campo Sant'Angelo here. Then two years after that, when I was in a very low patch in my life, she came to England and visited my studio, and we have remained friends ever since. So this watercolour is

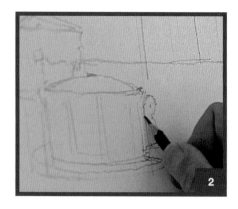 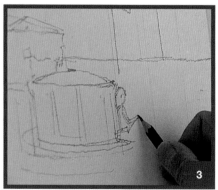 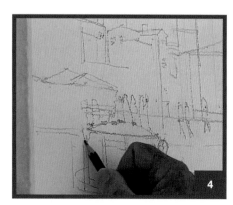

going to be a special one for me, because it reminds me of that day when I first did a watercolour of Dora.

2/3/4 Drawing in the shapes of the fountain and the background.

I was a natural draughtsman when I was young, that was the one bit I had that was given to me. I think anybody who does anything in the arts has one thing which is natural to them, the thing that makes them want to start to do it. I had this ability to draw.

One of the things you have to watch very carefully in this subject is the leaning tower. You can see it from all over Venice. I am always surprised where it pops up, you think you are miles away from it and all of a sudden there it is over the top of the roof. Somebody said an interesting thing to me the other day, which was that they had never got to the bottom of this tower. I never have, and I don't even know

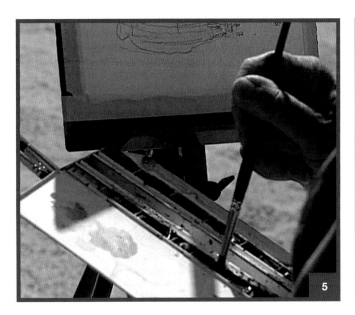

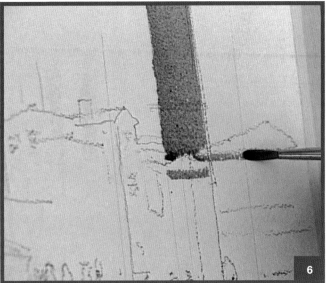

5

6

5 *Making up a colour. My watercolour paintbox is organised in a colour sequence that begins with transparent colours and then goes on to the semi-opaques and opaques.*

6 *When you paint or draw something that leans, be careful not to overdo the lean. The angle of this tower is actually very subtle. If it was not, the thing would fall over.*

which church it belongs to. You have got to be very careful that you don't lean the thing over too much, it's got to be extremely subtle. It's also a very subtle colour, it's got this lovely reddish note to it. So when I start I put in quite a bit of Alizarin Crimson.

What I want to get is that light on the top of the fountain. I love that effect, that's one aspect of midday that is lovely. It is interesting the way this subject grows. Very often in the morning the square will be empty and then gradually more people come and then the vendors start putting up their stalls. I'm never too bothered by that. Once you know a subject, you know what is going to happen during the day, but

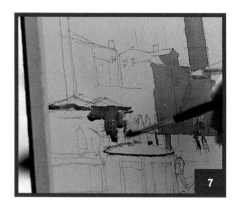 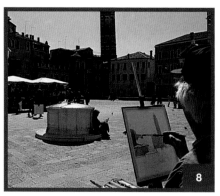 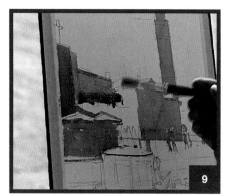

I very often let the subject grow, in a way, as I am working on it. I know you shouldn't. Corot said you must always keep true to your first impression. I agree with that to a great degree, but what it really means is your first impression of the light, or the time of day. It is no good working on a picture in the afternoon if you started it in the morning. But I think if things happen within the subject, then I don't mind adapting to them. For instance, when the stalls went up they gave more contrast to the top of the well in front. You can leave out, of course you can. I would say you can leave out but you must never add, simplify but never embroider. Simplicity is elegance. That may sound a bit trite, but it is very true.

You will notice in this figure, as I'm working on it, that the drawing isn't right. She's far too cramped up, but I am not that bothered because I will correct that as I go on with the watercolour. Drawing

7/8/9 Now I am using colour to reinforce the drawing, and lay in areas of the tower and the buildings in the square.

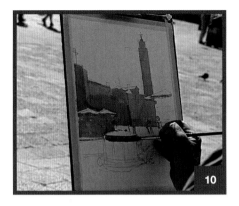 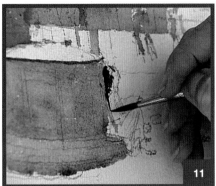 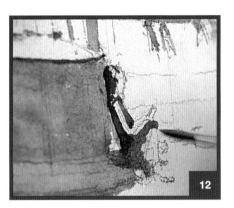

10 *Here I am strengthening the rim of the fountain. Some of this will be lifted off when I put in the main colour for the fountain, which is much softer.*

11/12 *My initial figure drawing was too cramped, so I am adjusting this with colour. It is actually a bad thing to use paint just to fill in your first drawing. That makes everything look far too mechanical. It is much better if you can use the fluidity of paint to give a rhythm to what you are doing.*

shouldn't be something that you fill in, drawing should be something that gives you your clues up to that stage. When you start painting, you are still in essence drawing but then you have gone on to drawing with colour. Very often when you start to draw with colour and you start to see the shape, you see it more clearly. In a way you should be drawing right up to the last mark.

Again, you can see that the colours I'm using are mainly earth-based. Although when I work with watercolour I have in my palette Cerulean, Crimson, Cobalt and the primary colours, still the base for me are these earth colours. I believe that nature is basically made up of earth colours. In this one I've hardly put in a bright colour. I know that Dora's dress is quite bright blue, but in relation to the light around her, the main thing for me is to find what tone it is in relation to everything else.

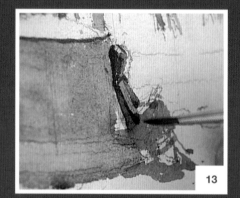
13

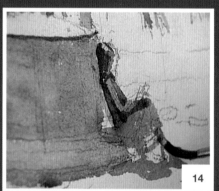
14

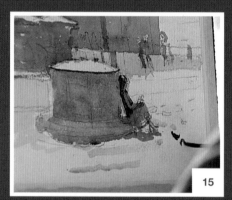
15

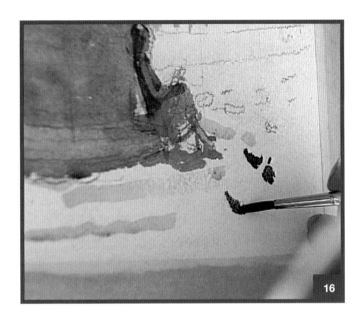

13/14/15 *Building up the figure. The dress that Dora is wearing is actually bright blue, but for my painting I have to choose a tone which fits in better with the scene as a whole. So the skirt is going to be more of a grey-blue.*

16 *Putting in the pigeons. All you have to do is just suggest the triangular shape of their bodies, with no more than a faint dab for the head. The legs don't come into it.*

Now I'm bringing in the accents of the pigeons – which if you're not careful you paint like chickens instead of pigeons – or geese. They get bigger and bigger!

I let the figures, particularly, grow as I see them. One of the marvellous things about that is that you've got to get on with them. I don't know how long that fellow's going to stand there, I don't know how long he's going to keep his weight on one leg like that, but once I've committed myself and want that vertical of the leg in relation to the well, I have to get it in quickly because he certainly isn't going to

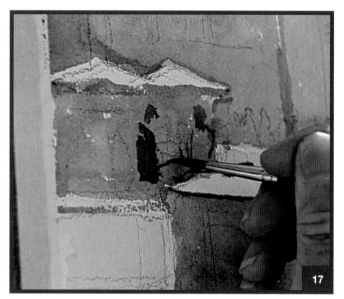

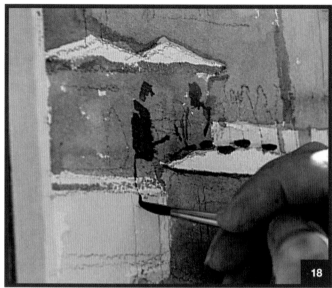

stand there more than a few minutes. So I've got to watch the
relationship of him to the background, the relationship of him to the
figure next to him, and so on. To a certain extent you can approximate
how long someone is going to be there, but you don't know and it
keeps you on your toes. You can't sleep when you're working on a
subject like this, and of course the light is moving all the time. The
pigeons are moving all the time, the figures are moving all the time,
nature is moving all the time. That's the wonderful thing about
working outside.

Now I'm drawing some detail into the tower, knowing jolly well that

17/18 *Catching a bystander. You have to
work quickly, so it is important to get the
basic shapes first. Then, for the clothing,
you can put your colour on, then wash it
off if you want to, and put it on again.*

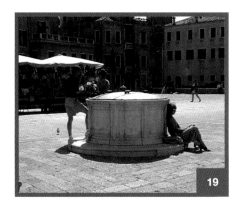 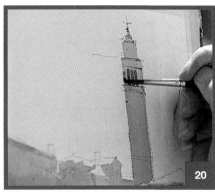 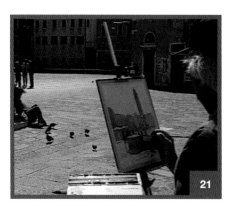

19 *Photograph at midday. Look how bright the light is on top of the fountain and on the canopies over the stalls. This only happens when the sun is directly overhead.*

20 *I am adding some detail on the tower, but I am not going to try and put in every one of its light-coloured bricks and so on. That is not what I am looking for.*

21 *The pigeons, windows and several other things in the photograph look quite black, but I never use black in watercolour. I don't have a black. Instead I make up my own tones, often a mixture of Raw Umber and Ultramarine.*

I'll be washing it off, putting a wash over it to thin it down. I'm not going to start fiddling around trying to put in every one of those light bricks and all the architecture exactly as it is. That's not what I'm about. I'm not making an architectural record of the Campo Sant'Angelo, I'm trying to get the feel of what the Campo Sant'Angelo is like this morning.

Now I'm getting a bit more detail into the background. Imagine if I left it like that, all you'd be looking at would be 'jumpy' sort of windows. I suppose in my mind's eye I know how I'm going to develop it, what my next bit's going to be, what I'm going to try and do. And that's the whole thing about experience, really. Not that you work to a formula, but when you're putting something on you know how you can bring the whole thing together again and stop it all just being jumpy.

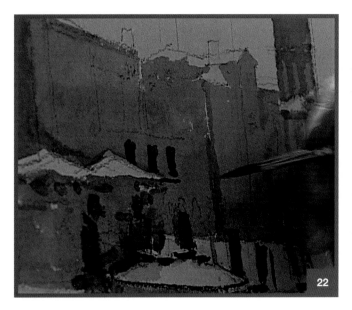 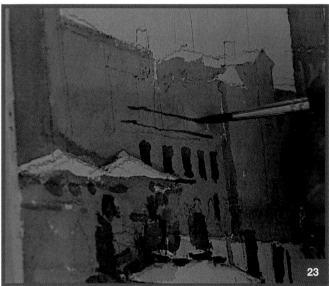

Now I'm being really daring and putting that blue sky on. I usually state the main colour. For instance, in the morning in San Marco I'll probably paint the sky Yellow Ochre to begin with, when it has that early morning warmth, and then glaze and do all sorts of things over the top of it. But in this one, because it's getting towards midday and the sky is quite blue I'm painting it quite blue. You may laugh and say, what do you mean, quite blue, it's still very washed out!

Although the square is relatively light, compared to it the top of the well, if anything, is white in terms of tone. So you've got to keep on looking at everything else around it, and when you're looking at

22/23 Putting more onto the building. First a row of windows, then a couple of horizontal lines which later will be washed over as I make all of the building darker.

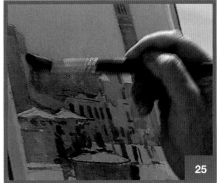

24/25/26 *Now comes the blue sky, which I am washing in over the whole of the sky, including the tower.*

everything else keep your eye on that light. The essential point here is that you can't paint light, because you haven't got a tube of it. So what you can do, to give an impression of something being light, is to suggest it by putting darker colours next to it, or around it.

Now I'm letting the wash run down over the buildings to keep the tonal sequence. In other words, working from light up to dark, letting wash go over wash. Every time you put a wash on, it lowers that tone. It's a very fine line, really, between underdoing something and making it all just nothing, and overdoing something and making it all staccato and jumpy, and slick.

There's quite a lot of red in those buildings, and now I'm letting the red run over, and the windows are really taking their place, back behind the figures and behind the canopies of the stalls.

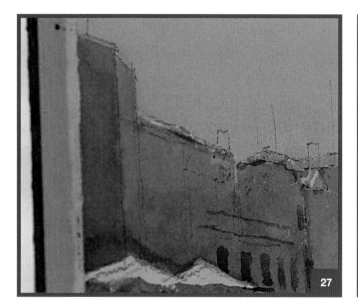

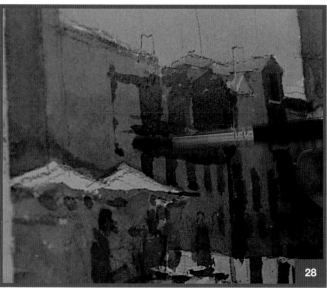

Now for the Chinese White, which I will use to pick out the brilliant overhead light from the midday sun. This is most clearly visible on the top of the fountain and on the canopies above the stalls, and also on some of the roofs of the buildings in the background.

Having used the Chinese White, I'm now returning to my sky which I'd started by painting it quite blue. As I've gone on with it, of course, that blue, that looked blue when it was against the white paper, is now looking less blue. And when I look at the sky I can't help seeing quite a lot of yellow in it, so I'm now putting a yellow wash over the sky and then letting it run over the buildings.

27/28 *Here I am giving the building more colour and warmth.*

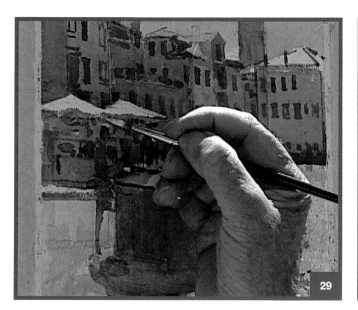
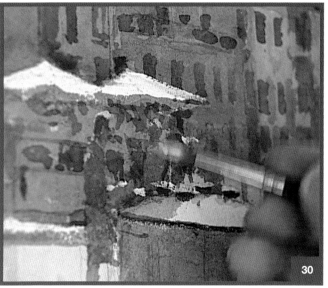

29/30 *This is the Chinese White in action. I am using it mainly for the tops of the stalls and the brighter part of the fountain, and also to pick up lights in parts of the foreground scene.*

I have a feeling that I've overdone the yellow, and when I look at the sky I think, no, it's still bluer. So you see I don't know the answer, I just keep on trying to get as near to the effect that I want. If it means me putting about six glazes on – a warm one, a cool one, a warm one and a cool one – then I will keep laying them on until I feel the effect is there, and then I'll stop. At the same time, I have to keep watching the light, and stay within the time frame that I have set myself for the painting.

So here is the finished painting. It's quite big for me, actually, for a watercolour. I'm quite pleased with this picture in terms of

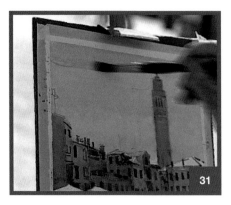

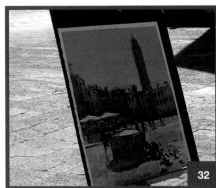

composition. One of the great difficulties of painting is getting the right scale of everything in relation to everything else, and in relation to the whole format of the picture. There's an atmosphere, there's a cushion of atmosphere between the background and the foreground and I think that's a thing we should all look for. Watercolour is a wonderful medium for giving that atmospheric effect to the colour.

31 *Now the sky seems less blue to me, so I am putting on a yellow wash which will continue down the buildings.*

32 *The finished painting against the warm, bright paving stones of Campo Sant'Angelo.*

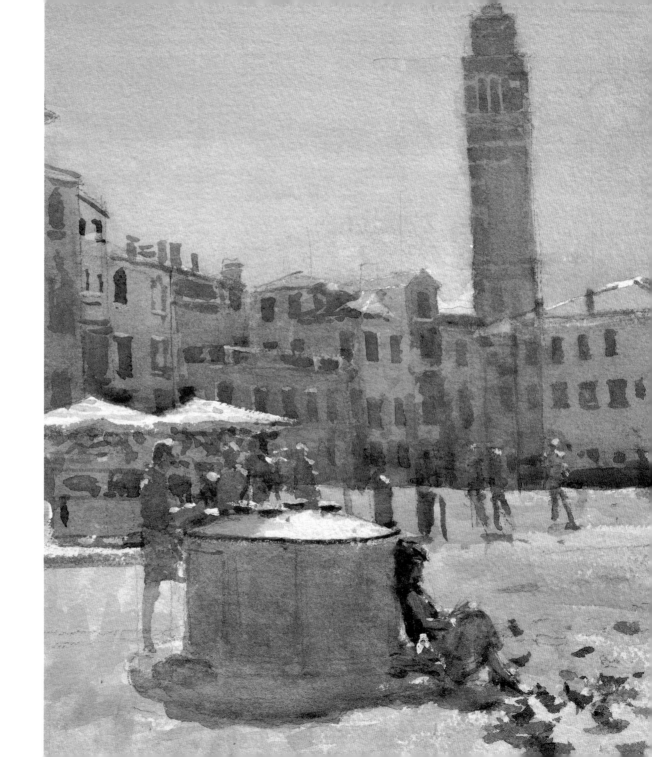

"Watercolour is a wonderful medium for giving

that atmospheric effect to the colour."

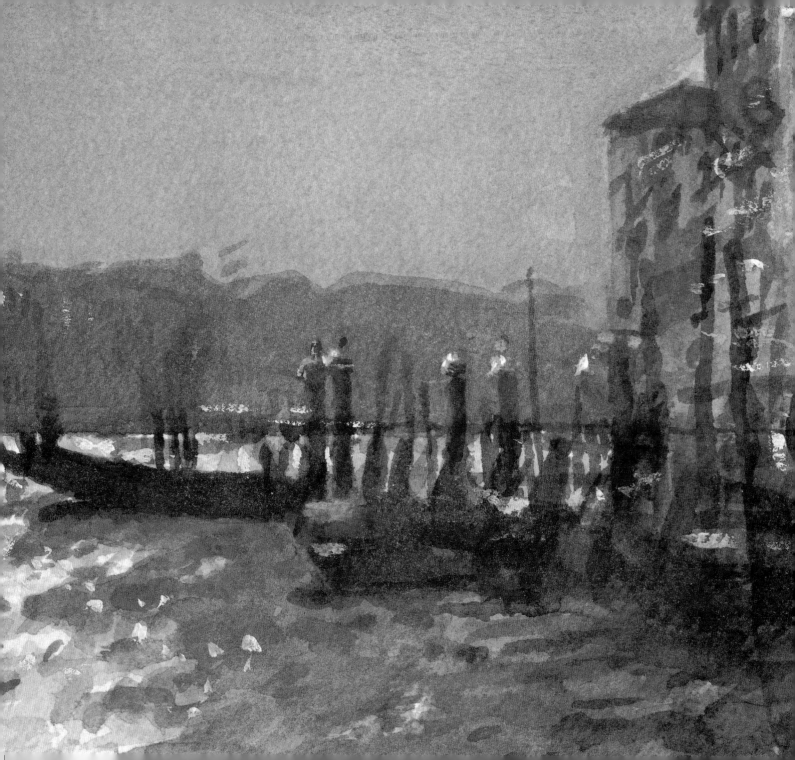

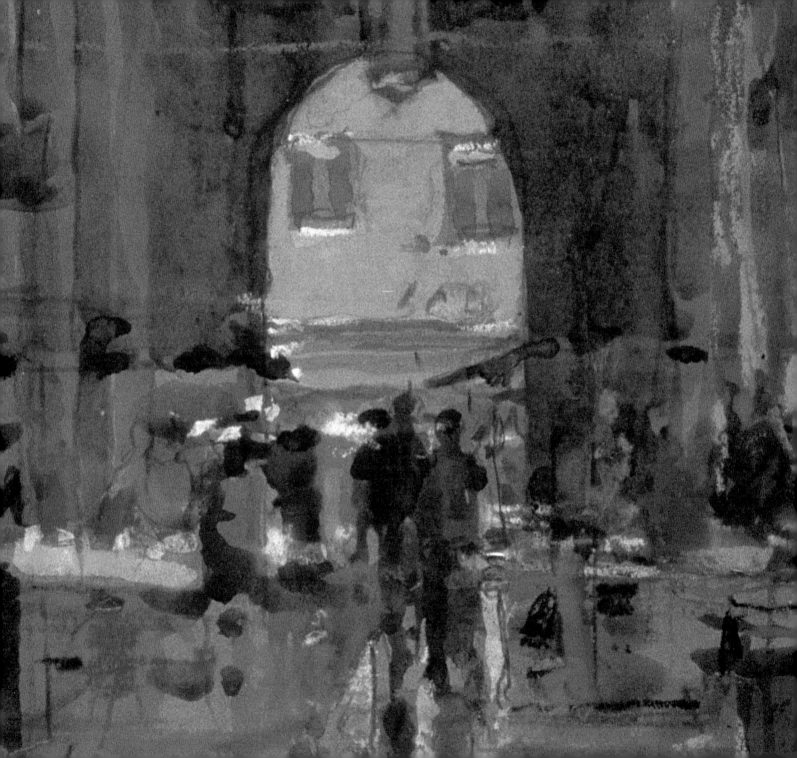

MERCATO DEL PESCE

Previous page *Watercolour with gondolas. Again I have used Chinese White to heighten the play of light on water.*

Opposite *Detail of the completed painting shown on page 89.*

This morning we're going up the Grand Canal to the Fish Market, which is another wonderful part of Venice. This morning we haven't got that marvellous sparkling light that we had yesterday. This is the sort of morning for which I purposely always have mixed media in my materials bag. If I worked in pure watercolour this morning, there would be something slightly dead about it, whereas the mixed media will bring out all this colour. If you're concerned with light, you're going to run into the same problems – the changing aspect of light and the changing aspect of every day. Of course, that in itself can be a marvellous thing because it centres the mind on a day, even on an hour, that you've got to get the thing down. I think urgency in a painting is a very good thing. The necessity to get the thing down is

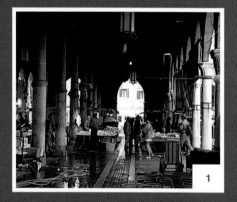
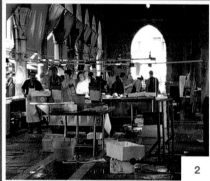

1 A long view of the market hall. I have decided to focus on the central arch at the end, and will come in a bit from this view, so that only the last four side arches feature in my painting.

2 This photograph highlights some of the brilliant colours inside the hall. The red blinds will not feature in my painting because of the way I have framed it, but I will anyway tone down the other reds and yellows.

3 Drawing in some of the architectural elements and various bits and pieces on the market floor.

good because that in itself brings a vitality to the marks that you make and you haven't got time to just be, as it were, recording fact. You've got to keep to your initial impression.

Now we're in the fish market. Obviously, this is such an enormous subject I could spend a whole week here and find subjects right the way across, but I'm just going to take the one view, looking down the market through the arch at the end. That arch at the end appeals to me tonally. This morning I'm going to work in a completely different way. I'm just going to mix everything I've got – some watercolour mixed with white gouache, pure watercolour, then some pastel on top – and gradually I'm going to try and coax the whole feel of the market rather than do a topographical description.

Because I'm working in mixed media, I'm working on a completely

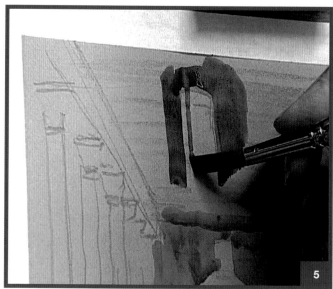

different paper. The ideal paper for today is a paper that's made for pastel which is called Canson or Fabriano. For one thing, it's always tinted, but you really do need to stretch Canson before you work on it. Stretch it the night before. If you do forget to stretch the paper, when you get back in the evening you can stretch it afterwards. All you do is turn it over, damp the back this time, where the painting isn't, and of course the paper then expands anyway just the same, and then stick that down on a board. When it dries it'll be stretched, and it won't have done your watercolour any harm. The thinner the paper, the more necessary it is to stretch it, and that's why I use a very heavy

4/5 *Painting in the outline of one of the lanterns and some of the background. Although this is a mixed-media work, I am still starting with transparent colours which I can wash over as I build up the picture.*

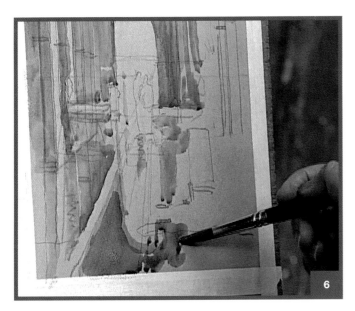
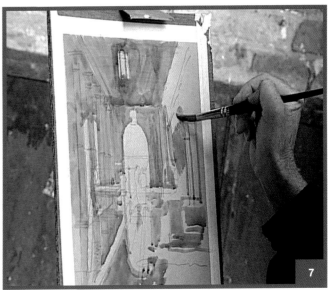

6 /7 *Warm tones for the more shadowy areas of the hall.*

Arches paper when I'm working in watercolour, with a weight of 300 lb (640 gsm) plus. OK, it's expensive, but when you think of watercolour paper in relation to canvases it's not expensive. And in watercolour I work on a smaller scale anyway.

Even though I'm working in mixed media, I'm still working with transparent colour to begin with, and I'll carry on working with transparent colour until I can't get the effect that I want. Then I shall start letting some gouache come into it.

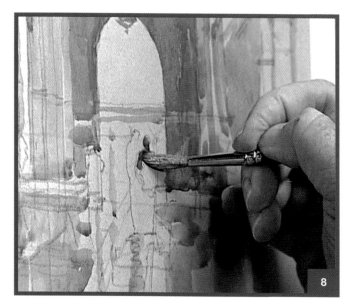

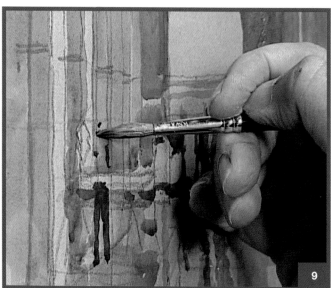

I'm going to give myself until half-past ten on this one, by which time the market will be beginning to close up, it being a Saturday.

The thing that struck me about this subject to begin with was the arch at the end, and the effect of inside against outside. That was, if you like, the moving thing for me. Then of course the whole space is full of wonderful touches of colour, whether it's the fish on the slabs or the things that people are wearing. Once again the subject is mainly made up of earth colours, of siennas and umbers and greys mixed with blues and browns.

8/9 When you paint incidental figures like these, look at them just as shapes and colours rather than as anatomical structures. Concentrate on bringing out what you actually see at that moment.

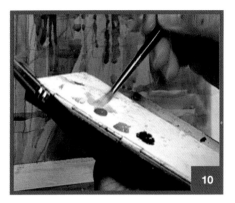

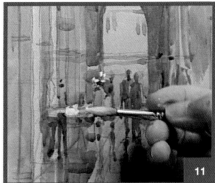

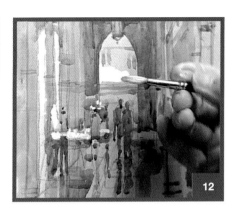

10 *Palette with gouache and body colour. For mixed-media work it is best to have two palettes so that your watercolours are kept completely separate. On this occasion I only had the one, so I had to keep the watercolours strictly apart on the other side of the palette.*

11/12 *These colours are Chinese White and body colours. I am adding them through the scene to pick up the bright colours on the fish stalls and other, smaller areas.*

The thing about painting figures is, it's no different from painting anything else. Those figures moving through the market are no more difficult or no more easy than the architecture or the fish or any other part. They're only shapes and colours made up of other shapes and colours in relation to each other. The thing is to keep on concentrating on what you are seeing is there, not what you know is there. Concentrating on how you see a figure, not on what you know a figure to be. All painting, in that sense, is abstract, no matter how we paint.

Although I'm working in body colour – by which I mean watercolour mixed with Chinese White to make it opaque – in fact most of the colours that I'm squeezing out to make my my body colour are in fact still watercolours. I don't use a lot of gouache as such, but by putting white with them I immediately make them equivalent to poster colour.

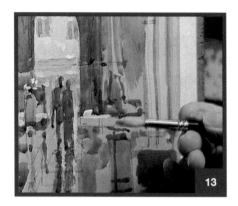 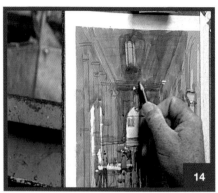 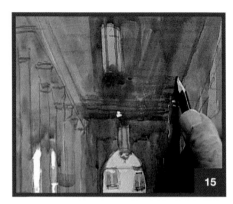

This is partly because when you travel you don't want to be carrying sacks of different types of colour. Watercolour is the ideal thing for the traveller. I'm now using the Chinese White almost like gouache. I'm mixing on the colour with it. I'm using it like Brabazon would have used it. You've got this wonderful light on the wall and the texture, but of course you can't go too far with that, you've got to keep the whole thing together. In this market the first thing you're conscious of is the whole effect, and therefore when you look at the picture the first thing you've got to be conscious of is this total effect. On the other hand, you could be what I call an episodic painter, and make your pictures about a lot of episodes, like music is sometimes. I try and paint pictures more like concertos or symphonies, that read as a whole.

13 *Further touches of Chinese White mixed with watercolour.*

14/15 *Using pencil on the ceiling to clarify the design and pull everything together.*

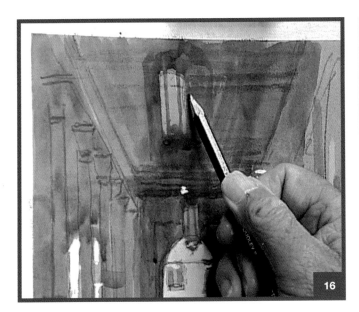

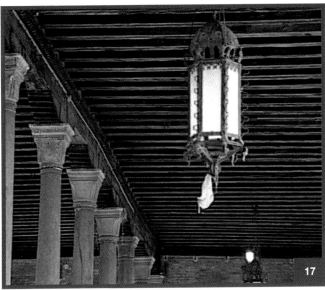

16/17 *I am putting in the lines of the beams in pencil, but I don't want to make them as pronounced as they appear in the photograph. Nor do I want the lantern to be as bright, since that would affect the tonal balance.*

The good thing about working in mixed media is that you build the drawing and the paint together. Every now and again I take the pencil and clarify the drawing, and in so doing I tell myself more about the colour and tone. Really, the two things go hand in hand.

Ideally, for working in mixed media, you should have two palettes (which I haven't got today). One is for your gouache and your body colour, and then your watercolour box which you use for your pure colour – because if you're not careful your watercolours will all begin to get white in them.

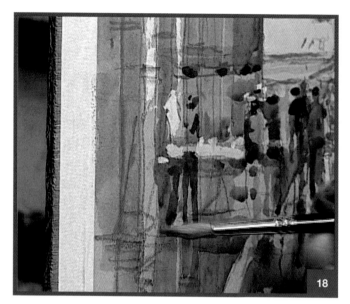

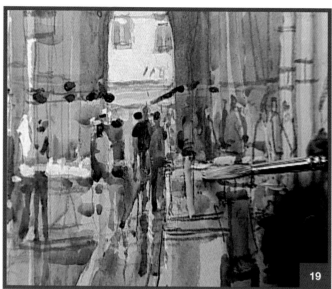

It's a bit bitty at the moment, I hope finally that I shall pull it together a lot more.

18/19 *More highlights and additional colour using various tones of gouache.*

The thing with all these media really, particularly with mixed media, is to find out for yourself what they do – and the only way to do that is by using them. It's no good anyone telling you what you can do, you've got to find out for yourself. People will give you clues about things, but in the end you've got to actually experience doing these things. The whole of drawing and painting is about practice.

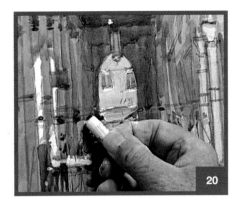
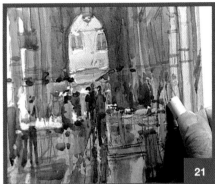
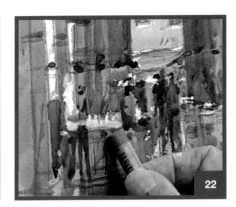

20/21/22 *Now it is time for the pastels. These have to be kept down to just touches, otherwise the pastel takes over and dominates the whole thing.*

You never lick your brush when you're working with gouache – at least you do, but not very often!

Now I'm using the soft pastel, which you can use just like Chinese White to put the light accents in a watercolour. You can pick up your colour with this because it will be much purer than if you put the colour on with gouache or watercolour. Pastel colour will give it quite a kick. There's a danger that it will give it too much of a kick, when you just want to give it that bit extra. I don't use it too much, but every now and again I work in this way and gradually the pastel takes over and it finishes up almost as a pure pastel. I don't really want that, I want to use the pastel almost like the highlights of colour, even highlights of tone, just picking up reflected lights. And it's there of course, as you can see in the photograph with the man in the red

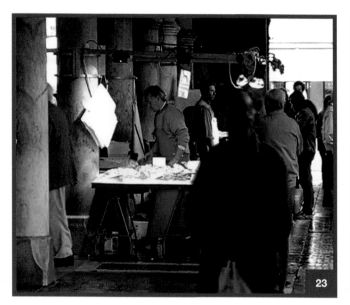

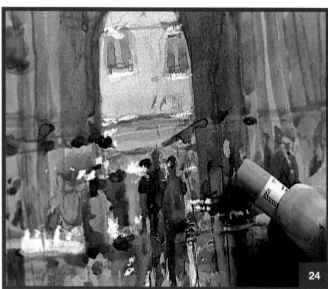

apron – that wonderful, vivid colour in the light interior of the fish market.

Painting, whatever material you are working in, is in the end trying to find an equivalent for the thing you're looking at. It's not trying to copy it exactly, it's trying to find an equivalent for it so that your picture gives back the sensation of reality, the feel of reality, whereas when you look at it closely all it is is lots of bits of pastel and bits of watercolour and bits of whatever else. But when you step back, those bits all add up.

23/24 *If you compare the bright areas in the photograph with the painted view, you will see that I have confined these pastel and other highlights to just small areas of the whole picture.*

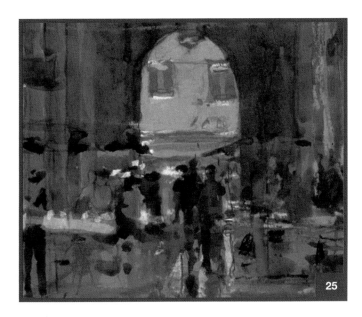

25

25 *Detail of the upper area of the painting, where the brighter colours are concentrated in a fairly narrow band across the market hall.*

With watercolour you automatically work closer, not only because you work on a smaller scale but also because, for me, watercolour and mixed media are, in the end, about drawing. It's not like with oil paintings, standing back and then seeing whether the thing pulls together. You may have noticed how, at the art galleries, people go up close to watercolours and gouache to look at them, whereas with oils people stand back across the room.

With a watercolour, sometimes you know when you've finished it whether it's worked or not, but with mixed media I often think, 'Oh

no, that's a terrible mess,' and then I look at it. With this one I felt all the time that it was too busy. The subject was busy, all those people rushing backward and forward, so my struggle, all the way through it, was to try and give a sense of busyness without the picture being busy. Now I wouldn't mind doing an oil of it. Very often one gets that sense after working in watercolour.

Opposite *The complete picture of the fish market.*

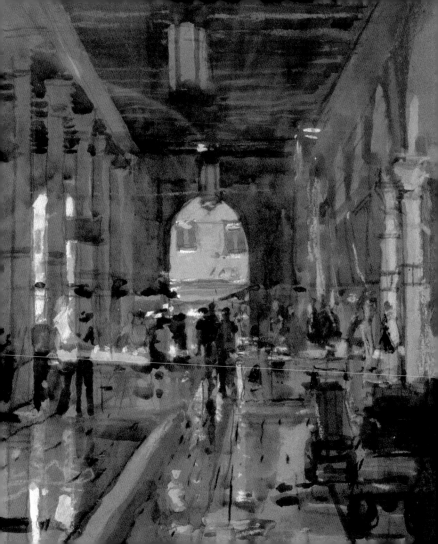

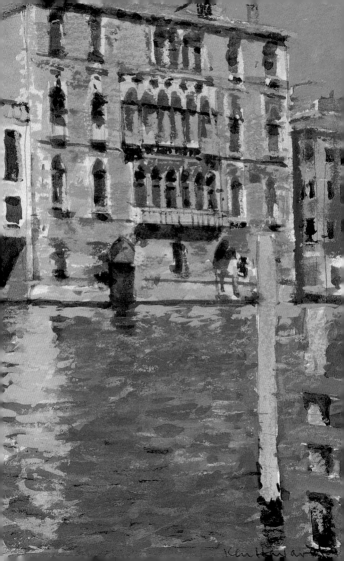

CONCLUSION

I hope this has given you some idea of my approach to watercolour, and particularly my approach to watercolour in Venice. Watercolour is very different from oil. With watercolour you can't mix exact tonal values, you've got to find an equivalent in watercolour for the image that you're looking at. This is a very complex thing and it's very much more about the senses than reason. It's about sensing whether something is right. To try and talk about how you paint and why you paint is extremely difficult. The only way you can talk about it is in terms of paint.

"of all the cities in the world Venice is the one that
celebrates life, it celebrates light, it celebrates art..."

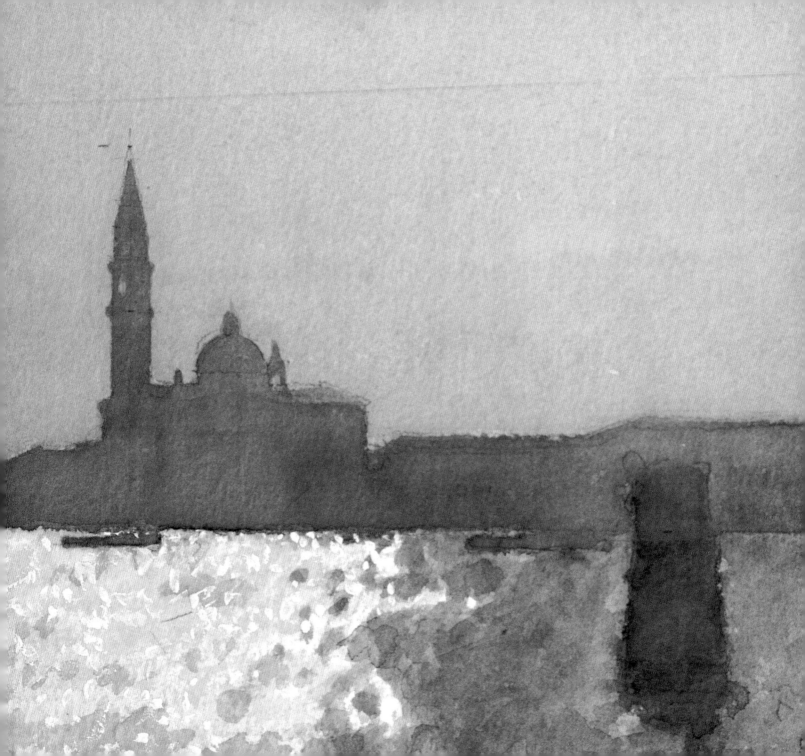

SOLO EXHIBITIONS

1955	Plymouth Art Centre	

1955 Plymouth Art Centre

1966 John Whibley Gallery, London

1968 John Whibley Gallery, London

New Grafton Gallery, London

1972 Plymouth Art Gallery – Retrospective Exhibition

1974 New Grafton Gallery, London

1976 New Grafton Gallery, London

1978 New Grafton Gallery, London

New Metropole, Folkestone

Hong Kong Art Centre

St Helier Gallery

St Helier Gallery

New Grafton Gallery, London

Nicosia

1983 Delhi

New Grafton Gallery, London

St Helier Gallery

New Grafton Gallery, London

Linton Court Gallery

1987 Lowndes Lodge Gallery, London

New Grafton Gallery, London

1989 Lowndes Lodge Gallery, London

New Grafton Gallery, London

Lowndes Lodge Gallery, London

Lowndes Lodge Gallery, London

Brian Sinfield Gallery, Gloucestershire

1992 Lowndes Lodge Gallery, London

1993 New Grafton Gallery, London

Brian Sinfield Gallery, Gloucestershire

New Grafton Gallery, London

Brian Sinfield Gallery, Gloucestershire

New Grafton Gallery, London

1998 The Everard Read Gallery, Johannesburg

New Grafton Gallery, London

The Everard Read Gallery, Cape Town

2002 Richard Green, London.

JOINT EXHIBITIONS

Ken Howard has exhibited regularly at the Royal Academy
since 1952. Also with:

New English Art Club since election in 1962 (he is now the President)

Royal Institute of Oil Painters since election in 1966

Royal Watercolour Society since election in 1979

Royal West of England Academy since election in 1981.

PUBLIC COLLECTIONS

Plymouth City Art Gallery

Sheffield Art Gallery

Hove Museum and Art Gallery

Guildhall Art Gallery, London

Imperial War Museum, London

National Army Museum, London

Ulster Museum and Art Gallery

SELECT BIBLIOGRAPHY

Michael Spender, *The Paintings of Ken Howard: drawn by light*,
Newton Abbot, 1992.

Sally Bulgin, *Ken Howard, a personal view: inspired by light*,
Newton Abbot, 1998.

VIDEOS

Ken Howard: Inspired by Light – Painting in Oils (1996),
made by APV Films

Ken Howard: A Vision of Venice in Watercolour (1998),
made by APV Films for the Royal Academy

Ken Howard: A Vision of Venice in Oils (2000),
made by APV Films for the Royal Academy.

ACKNOWLEDGMENTS

A Sears Pocknell book

Editorial Direction	Roger Sears
Art Direction	David Pocknell
Editor	Michael Leitch
Designer	Jon Allan

This book is adapted from the video: *A Vision of Venice in Watercolour*
All video images copyright © 1998 Artwork Films Ltd.
Video produced and directed by Anthony Parker for APV Films
Video available from

APV FILMS
6 Alexandra Square, Chipping Norton, Oxon OX7 5HL

British Library Cataloguing-in-Publication Data

A catalogue record for this book is available from the British Library

ISBN 1-903973-08-2 (hardback)

Distributed outside the United States and Canada by Thames & Hudson Ltd,
London. Distributed in the United States and Canada by Harry N. Abrams,
Inc., New York

Originated in Hong Kong and printed in Spain by Imago

RA Publications, Royal Academy of Arts, Burlington House, Piccadilly
London, W1J 0BD, T 0044 (0)20 7300 5660, F 0044 (0)20 7300 5881

Half-title page illustration: *Casa Stecchini, evening*, watercolour
Title page: *Rio di San Lorenzo*, watercolour
Contents page: *SS Redentore from Campo San Giorgio*, watercolour